W9-CBU-187

LETTERING & ALPHABETS

by J. Albert Cavanagh

Dover Publications, Inc., New York

Published in Canada by General Publishing Company, Ltd.,
30 Lesmill Road, Don Mills, Toronto, Ontario.
Published in the United Kingdom by Constable and Company,
Ltd., 3 The Lanchesters, 162–164 Fulham Palace Road, London
W6 9ER.

This Dover edition, first published in 1955, is an unabridged
and unaltered republication of the work originally published in
1946 by Halcyon House under the title *Lettering*.

DOVER *Pictorial Archive* SERIES

International Standard Book Number: 0-486-20053-1
Library of Congress Catalog Card Number: 56-3226

Manufactured in the United States of America
Dover Publications, Inc., 31 East 2nd Street, Mineola, N.Y.
11501

Lettering

J Albert Cavanagh

DEDICATION

This edition of *Lettering and Alphabets* is dedicated to the memory of J. Albert Cavanagh for his contribution to the art of lettering and to the teaching of lettering in America.

CONTENTS

Introduction

In preparing this book I was concerned principally with the practical application of the fundamental lettering styles as shown on the following pages. The art of lettering has advanced rapidly in the past few years due to the keen competition of artists and the added appreciation of the importance of hand lettering by those responsible for modern advertising.

I have omitted the history of lettering from this book as that subject has been covered comprehensively by other books. It is my idea to simplify this work and make it easy for the student to understand just what is wanted today by progressive art directors.

Present day advertising is demanding more from lettering artists than ever before. It is not enough that lettering artists be able to execute lettering that is mechanically perfect. They are expected to be creative, artistic, versatile and trained so that their minds will be able to visualize not only their part of the work but also that of the other artists and artisans who co-operate to make the completed advertisements.

Few lettering artists can afford to specialize. A professional letterer must have the ability to do well every kind of lettering. Above all the artist who hopes to win top-flight rating in his profession must know lettering so thoroughly that he is able to adapt existing styles to each particular job and also, when the occasion demands, create what appears to be a *new* lettering style.

It would be an untruth to say that there are better lettering artists today than have lived in the past. But it is a fact that there are *more good letterers* now; and it is also true that present day lettering artists are, and must be, much more versatile than those who practised the art previously.

The uninitiated would be greatly surprised at the tremendous amount of lettering that is used by advertising agencies. Lettering on roughs, comprehensives and visuals

3

alone keeps a great many artists profitably employed the year round. There are wonderful opportunities for artists who excel in the intelligent application of lettering, but they *must understand lettering,* and its uses in the advertising page.

Lettering, when used correctly, by itself can create almost any desired impression, express an idea, and even lend distinction to the advertising page. It can suggest quality, charm, action, speed, beauty, dignity, character, etc. Hand lettering can be made to fit awkward shapes and spaces where typography cannot be used. It should carry the message to the reader in the simplest and most pleasing manner. The good lettering artist thinks not only of the shapes of letters but concentrates on the most effective and practical use of the letters and the idea intended to be conveyed by the words which the letters spell.

Only the professional with a thorough background and years of sincere study should attempt to design letters. The actual finishing or inking in of letters is not so very difficult but the artist must know the correct shape and proportions . . . the basic characteristics . . . of the particular style of lettering on which he is working.

LETTERING IS AN ART. The student must appreciate that all competent art directors are able to tell immediately when the worker lacks the necessary experience and versatility to do a variety of satisfactory work. I, therefore, caution every lettering student to set a high standard for himself so that when he does lettering it will have a professional touch. One should constantly bear in mind that lettering does something that type cannot do; otherwise it would be better to set the lettering up in a good type. Lettering artists must constantly raise the standard of their work to hold their market.

Instruction

In the following pages of instructions I shall endeavor to explain in a simple manner the things that give lettering style, action, character, etc. Personally, I do not place too much emphasis on the shape of letters when teaching. I place special importance on the white space and design within and also around the letters themselves. This helps spacing and legibility. Extra care to secure correct weights and proportions gets more style, character, etc., into the lettering. Far too many artists limit their chances of becoming great designers by studying shapes of letters in one proportion only. Even the simplest letters should be drawn differently when made in different proportions.

Note the individual strokes in examples numbers 1 and 2; also note the white spaces in and around the letters to which the small arrows call attention in these examples.

I am a firm believer in freedom in lettering. On pages 62 and 63 are examples of free lettering which has great charm when done well. Working rapidly on this style of letter gives the feeling of more speed and action and retains the natural brush strokes.

Most students try to use styles that can be done mechanically and avoid the Caslons and Garamonds which require great care in their drawing. One should use the style of letter that fits the job regardless of how difficult it may be to execute.

The artist should first plan his work on tracing paper; then make the necessary changes and corrections (such as spacing, weight, etc.) by erasing, or retracing on another piece of tracing paper. When all corrections have been made, he should then trace it down with a hard pencil (6H) first rubbing the back of the tracing with a soft pencil (about 4B). Too soft a pencil for this might

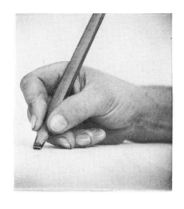

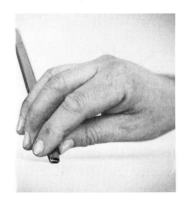

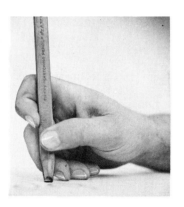

smudge the paper and make a very careless and unprofessional looking layout. Next measure the heavy bars of the letters with a compass or a piece of paper marked on the edge by a couple of marks spaced to the width desired. When transferring the work to the final paper do not bear down too heavily as you might cut or tear the tracing. After tracing two or three letters lift up the tracing so that you can see how it is transferring. When this is finished you can go over and strengthen, if necessary, these light lines that now show on your drawing paper (using about an H-B pencil). It is then ready for inking.

All this seems like a lot of work but actually it saves time and should result in a cleaner and more professional-looking job. As you become more proficient you may be able to drop one or more of these operations. This method is especially good when working on colored backgrounds. However, when working on dark backgrounds apply white chalk to the back of the tracing instead of a soft pencil. Rub off the surplus chalk with the palm of the hand before transferring and you will have a good clear letter on your background without smudging. When inking the finished work use a pen to fit the size of the lettering; on large letters use about a No. 303 pen and on small letters a No. 290. For most of my work I use a No. 170 which is about half way between the two sizes.

Most lettering should be inked in freehand but there are certain styles that can be done mechanically very well. In a very short while a student will be able to tell which way a job should be done. Some of the best letter-

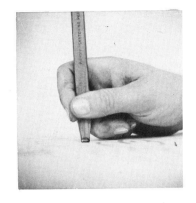

ing men use a flexible pen like a No. 290 to rule their lines so as to get a straight line and at the same time one which is not too mechanical. This difference can be detected only by the experts. Most of the artists fill in their lettering with a pen that is not too new instead of using a brush. In this way they get much blacker lettering and when they erase the pencil marks the ink does not rub off.

Many beginners make their finished lettering too large and consequently it loses style when it is reduced for reproduction. The artist should watch such details very carefully, even as to the quality of paper on which the finished work is done. A hard paper is best for pen work.

The artist will find it advisable, when doing a finished ink job, to fill in his lettering as he goes along rather than doing it entirely in outline and then filling in. This enables him to judge the "color" and legibility of the word.

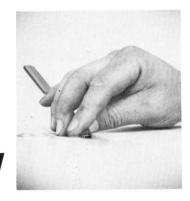

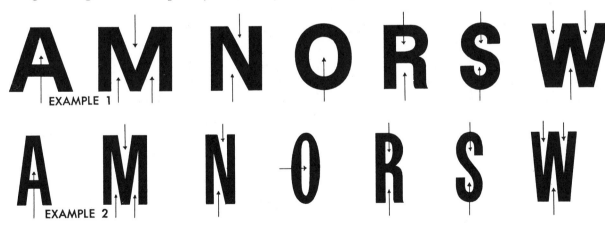

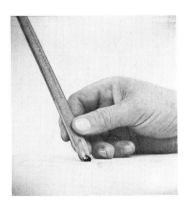

The italic, or slanting, letters may have more or less slant than is shown here. These are the kind of liberties one may take when using this book.

Don't start finished drawings until you are sure that you have decided on the best style of lettering for the job. In doing heavy letters be careful to watch the white spaces described in examples No. 1 and No. 2 on page 7. Watch the weights of the letters that have heavy down strokes and light cross strokes. You can easily lose style by making the down strokes lighter and the cross strokes heavier than they should be.

style has character and individuality when used intelligently. I have placed particular attention on the proportions of letters which I think are the basis of style in lettering. There can be many variations of weight and proportions not only in the letters themselves but in the serifs of the letters.

There are so many varieties of lettering and so many ways of introducing variety that it requires a finished artist to get the maximum results on the completed work. The lettering beginner and student should not venture too far from the honored and familiar forms of letters

EXAMPLE 3 # CAREFUL SPACING

Hand lettering for the printed page must blend with type and therefore needs to be very well drawn. This means that the artist has to take time and be careful. Many alphabets are shown on the following pages and each

that have stood the test of time, like Caslon and Bodoni, examples of which will be found on pages 42-47.

Really good lettering cannot be rushed to the point of sacrificing style and character for speed. Don't think

Companion

EXAMPLE 4

Companion

EXAMPLE 5

Companion

EXAMPLE 6

because a piece of lettering has been accepted that it is all right; this leads to carelessness. Lettering that is O.K. for signs and showcards might not make good headlines for the magazine page. Signs and showcards have to be done very rapidly and at a price that does not permit the artist to take much time.

If the artist considers the entire area of white space between letters he will soon acquire "feeling" in spac-

9

ing. However, important as it is, spacing alone will not make a good job of lettering. Characters of letters should be considered, as in example No. 1. It is not necessary to have all center crossbars on a line when all letters are light weight. The heavier the letter the harder it is to keep the crossbars on the line, as example No. 2.

It is impossible to overstress the importance of spacing because good spacing is absolutely necessary to make lettering legible and interesting. Mechanically measuring the space between letters seldom gives good spacing.

letters in words far more than would ordinarily be done.

Letter spacing should be used very intelligently and, I might say, sparingly. Too much copy letter-spaced is very hard to read. Title pages and letterheads work out very well with letter spacing and it is often used by artists on work of this kind.

COMPACT or CONDENSED LETTERING is in constant use as it permits making the letters taller in a given space. The spacing in compact lettering is most important as the white spaces show prominently and unless correctly

CONDENSED LETTERING

EXAMPLE 7

Spacing should be done with feeling, inasmuch as two straight letters like "N" and "I" should not be as close together as "N" and "O". The contrast between the straight letter and the curve of the "O" makes its own separation.

LETTER SPACING is that practise of separating the

done will ruin legibility. A good lettering artist takes advantage of every shape and thickness when working on condensed letters. If the beginner wants to give himself a test he could do no better than to take some long word and make it fit a short space without reducing the height of the letters or making them too "skinny."

EXAMPLE 8

Caslon Italics

Caslon style lettering is perhaps the most important of all styles for the lettering artist to be able to do well. It is unquestionably the most famous type style ever created. Ever since Caslon was first introduced its popularity has continued and grown. It is a style decorative enough to be in high favour for book covers, title pages and other such uses and yet it is so readable that it is widely used as a body type. Caslon styles are very difficult to draw well; the slightest difference in the proportions of the letters . . . the smallest change in their relative weights . . . changes their entire appearance and causes them to lose the characteristics which so unmistakably are Caslon.

Caslon capitals are graceful, beautiful letters when expertly drawn. They never should be drawn condensed since it is impossible to draw them in that form and still keep them Caslon.

The Caslon lower case is equally attractive if well planned and executed. Some artists do not appreciate this beauty until after they have acquired extensive experience and feeling in lettering.

A word or two of warning: be sure to avoid getting a "stringy" look to this style and work so as to keep the correct contrast between the heavy and the light lines.

Caslon Italic is the most interesting of all lettering styles because its design endows the letters with unique character, distinction and charm. Printers seldom hesitate and layout men are never wary about specifying Caslon Italic due to the fact that its rare beauty makes it adaptable for almost every piece of printed matter.

I place major importance on this letter style in teaching lettering. There is no more beautiful letter when it is properly drawn. It embodies the fundamentals of all Script letters and the artist who can draw Caslon Italic

CASLON

EXAMPLE 9

well will be able to letter Script with equal facility and perfection.

Hand lettering gives the artist an opportunity to dramatize Caslon Italic according to his individual ability. He may give it a little more slant or he may design it with more of a condensed feeling than the type has. Sometimes a heavier or larger capital letter for the first word starting a sentence lends additional interest. There are so many variations possible with Caslon Italic that every artist should practise to improve himself on this style whenever the opportunity affords.

ing must be infinitely more careful about every letter so as to give the complete work the true Caslon character.

Caslon Italics is very popular and is used in almost every kind of advertising. The artist who can letter Caslon Italics well will have almost no trouble at all when he attempts to do Formal Script styles.

The Caslon styles in this book are not supposed to be just like type but are meant to have a handlettered look, being more compact than type, but retaining the true characteristics of the Caslon style. The Bodoni types have been lettered with the same idea in mind.

Caslon

EXAMPLE 10

The flat pencil renderings on page 26 show the style done in the rapid way that the modern art director works in making layouts. The artist who does the finished letter-

Each artist may take liberties with these types according to his own ideas without, of course, departing too far from the original Caslon and Bodoni characteristics.

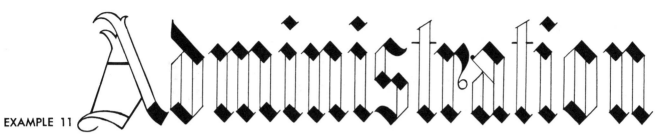

EXAMPLE 11

Caslon, Bodoni and Garamond are very old types and have stood the test of time, and today they are still among our most popular types. They are hard for the artist to do well because they require careful drawing but are important for him to know because they are used so extensively.

The layout of the lettering plus the "color," proportion and design all help to give character and style. Just

me the slightest difference in the proportion, weight or slant of a letter can make or mar the complete job. It may even be so small and seemingly unimportant in detail as the length or weight of a serif that makes the difference needed to give the lettering the desired style and character.

Example No. 11 is the basis of the English Gothic types on pages 60 and 61. The black angles on top and bottom of the example show the student what he must watch for

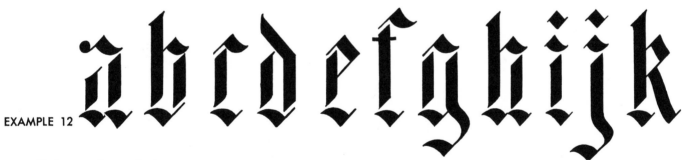

EXAMPLE 12

one little word poorly lettered can spoil a whole page; on the other hand, sometimes it takes only one well lettered word to give a page unique distinction and charm. To

in this style of letter as the shape and slant of these angles influence the spacing. Note the white spaces in this word and it will be seen that they are about the same weight as

Administration

EXAMPLE 13

the down strokes of the letter. These proportions may be varied some, but it is best in learning this style to start with about these proportions. The more experienced the artist the more liberties he may take with these proportions.

Example No. 12 of this style shows the individual strokes not connected. This illustrates the natural forms made by a chisel point pencil or square nib pen. This style

letter is often done with a chisel point pencil, pen and brush. Simply by connecting the upright stroke to the serifs the letter is complete. Try doing your lettering this way first and you will soon understand this style.

Example No. 13 shows the complete word "Administration." This character of letter suggests rhythm, and is used for that reason. In olden times this style was used extensively on a great variety of documents. Many books

Christmas

EXAMPLE 14

Christmas

EXAMPLE 15

Christmas

EXAMPLE 16

14

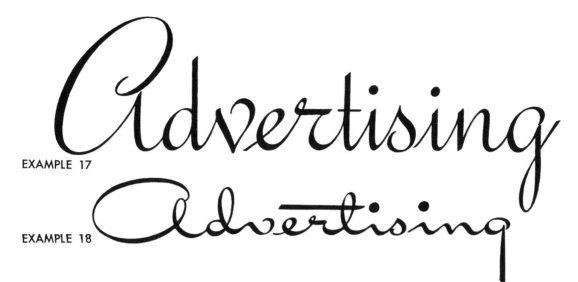

EXAMPLE 17

EXAMPLE 18

were hand lettered in this style. Today many resolutions and diplomas are done in English Gothic or variations of it.

Examples No. 14 to 18 inclusive are the basis of Upright Scripts (I call examples 14-15-16 the foundation of all upright scripts). While this example is somewhat varied it definitely shows the contrast between the upright and slanting lines (indicated by the example lines). These fine, or light, lines I call the STYLE LINES. The flat pencil examples on page 30 show this style drawn with more freedom.

Example No. 18 is the same style only much more extended. These letters can be condensed or extended to suit the work.

Formal Scripts, like the words "Stylish" and "Penmanship" (examples 19-20), find their origin in steel engravings. The character and proportions of the letters have become quite definitely established through many years of use and like many other formalities any very radical departure is frowned upon.

The lettering artist may however vary the slant and

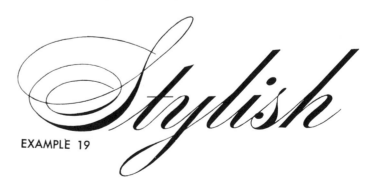

EXAMPLE 19

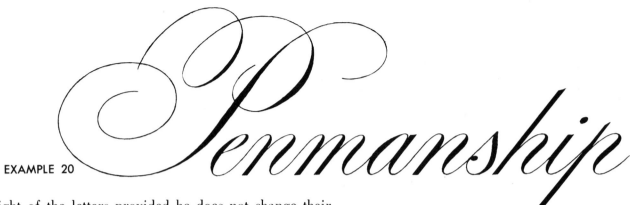

EXAMPLE 20

weight of the letters provided he does not change their proportions. When drawn too heavily it is no longer Formal Script.

The capitals may be varied for modern advertising purposes but only slight changes are permissible in the lower case letters. Many fine examples of this style are to be found in documents, resolutions, announcements, deeds and other papers executed during the 17th and 18th centuries. Some of these are so beautiful that they are difficult for the beginner to appreciate. He sees only the flourishes and does not realize how nicely the letters are drawn.

The purpose of showing the two examples "Admiration" and "Womans Home Companion" is to illustrate graphically the fact that action can be secured in loop as well as in straight line letters. Despite the fact that

the letters in "Admiration" slant while the "Womans Home Companion" is upright, I have given action to "Womans Home Companion" by lettering with a continuous motion and by making the loops of the letters oval instead of circular.

Both these words could be drawn with more freedom; but, from the instruction point of view, I think it is better to start with the basic idea of handwriting and as you become more proficient you can put in your own variations, individuality and character to give your style distinction.

I know of no more interesting styles with which to experiment than the various styles of handwriting. By using different pens and brushes you can get almost any desired effect.

EXAMPLE 21 *Admiration*

The word "Admiration" is practically a one-weight letter done with a speed ball pen and touched up afterwards. Because of its simplicity, and because it is easy to do, it is used extensively throughout advertising. The important thing to watch when lettering this style is in

This is a very free upright style of handwriting. It has many variations. Because of the individual character that each artist has in this style, I expect it to be popular for a long time. It produces a very pleasing effect when used with some of the formal types. I think every lettering artist should study these free types of handwriting until he has mastered them. If you will experiment with various

A Woman's Home

EXAMPLE 22 *Companion*

making the connecting strokes. That is where the action comes in this style of letter. The weight of the letters will govern the amount of action you are able to get into these lines. No matter how heavy you make the letters, the same general stroking will have to be followed.

pens and brushes, you will see how the different characters are arrived at. Don't underestimate this style as it has so many advantages. Letters of this style seem to need a more careful layout than formal types and therefore the artist should strive to think of the design of the entire

page. The weights of the individual letters should not all be the same. This will give your work a much freer and more individual appearance. "Companion", page 24, example 35.

EXAMPLE 23

This style is an adaptation of that on page 59.

The changes are in the placement of the cross-bars. In these two words there are so many cross-bars that it is the part of good art to utilize them in creating a design.

slightly beyond the letters will give added distinction to the words being drawn it is permissible to do that.

In most combination of words there will not be sufficient cross-bars to form a pattern. The artist should study the copy to be lettered and if a design cannot be created artistically the cross-bars should be in the center of the letter, as on page 59.

This style can be drawn either very light or very heavy but the light letter is generally to be preferred for most work.

Although example 24 shows the open letter treatment applied to a upright letter it is equally effective with a slanting letter. Most of the popular alphabets are adapted to open letter treatment the exceptions being extra heavy, or "brutal", letters.

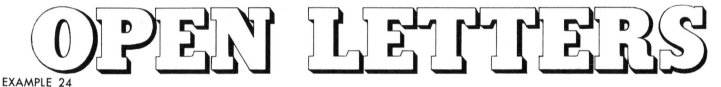

EXAMPLE 24

This is accomplished by placing the cross-bars below the the center of the letters.

If the artist has the feeling that extending the cross-bars

This style letter is used much more frequently in magazine than in newspaper advertisements. Frequently an open letter is used as an initial letter and a second color

used to fill the open space. The technique used in producing the open letter results in creating an impression of delicacy, lightness, softness and other similar qualities.

Open letters almost always are used in a large size to make for readability. They do not read well from a distance due to the fact that the letters "vibrate" too much; therefore open letters are seldom, if ever, used by professionals on posters, display cards and similar advertising.

their legibility. This letter should always be drawn free-hand without the use of ruling pen or other mechanical aids. While it is a style which requires skill and practise to do superlatively well there is sufficient freedom and looseness about it so that a comparative beginner can do the letter fairly well.

A few years ago this letter enjoyed great popularity. Lately it has not been used so frequently. I am including it in this book because a letter with so much character

EXAMPLE 25 Round Serifs

The words "Round Serifs", Example 25, shows a letter with heavy, rounded serifs and very little contrast between the heavy and the light strokes.

The well distributed weights and the natural separation accomplished by the heavy, rounded serifs make this an almost ideal letter for posters and for copy which must be read from a distance. It is not necessary to have all the letters on a perfectly straight line; also they may be condensed somewhat without materially affecting

and such wide utility cannot remain in the background very long and I predict its return to favor with advertisers.

Using the style in Example 26, it is easy to secure a dominating effect with a small letter. It is a contrasty and decorative letter. This style looks well when used with a one-weight script or handwriting style.

It will be seen that the down strokes are extra heavy while the cross strokes are extremely lightweight. For posters, and other work which must be read at a distance,

the light lines may be strengthened. Also the style may be varied by lengthening or shortening the ascenders or

mands attention. This style is particularly adapted for posters, book jackets and folders. I advise the student

EXAMPLE 26 **Cosmopolitan**

descenders as the need dictates. The corners may be rounded as shown on pages 102 and 103. The white spaces must always be kept proportionately small so that the letters will be readily legible.

BARNUM TYPE

EXAMPLE 27

This letter is quite popular and will be for some time because it is about the only letter in which the cross-bars of the letter are more prominent than the down bars, or strokes. This gives the letter great distinction and individuality and when well lettered com-

not to do this style too mechanically. When condensed or extended it has real style but loses much of its charm when done half way between these proportions.

Example 28 suggests power and emphasis in lettering. Emphasis generally is secured by contrast, yet, in the final analysis it is something far more subtle.

It is a very simple matter to place heavy block lettering against a field of white or to use white letters against a black background. While the artist doing this may have secured contrast he may have failed to achieve Power, *true emphasis.*

The real suggestion of Power depends almost entirely upon the proper relationship of the black area to the white area, or vice versa. Which is simply another way of saying that the artist must use exceptional judgment in proportioning the letters.

ADVERTISING

EXAMPLE 28

Newspaper advertising is beginning to use Power lettering with increasing frequency. The fact that a newspaper is read while held fairly close to the eyes does not lessen the need for legibility. It does, however, affect the ratio between black and white space and calls for more accurately drawn, tighter letters than are used on posters.

Direct literature and booklet covers require treatment according to the technique of the accompanying illustrations, the product and the form of reproduction that will eventually be used.

It requires an experienced artist to get the maximum effects with Power letters. Once the technique of their use has been acquired a great variety of interesting work can be done.

Pages 85 to 111 contain many examples of Power lettering. Any of these styles may be varied according to the conditions under which they are to be used.

Pages 88-89 and 90-91 are about the same style alphabets done in different proportions. These two examples will help show the student the various changes necessary when the proportion of the letter is changed.

It is extremely important that the lettering student should realize the need of exercising great care on each individual stroke when drawing these Power or heavy letters.

Other styles shown in this section may be treated in the stencil manner similar to the stencil style shown on page 68.

And as a final word of caution I warn all artists using Power lettering never to sacrifice legibility for strength because if the lettering cannot be read there is no message for the reader to remember.

EXAMPLE 29

EXAMPLES 29-30-31

These three examples are called Balloon Lettering because of their continued use in balloons. This is a style of lettering which has no definite shape but may have

EXAMPLE 30

slight differences depending on the artist. However, all the leading artists have the same basic idea behind their balloon lettering. On every job they allow the brush or pen to do most of the work. The brush because of its flexibility will give more character to the letters. A pointed *or water color* brush will give the best results. Use of a

EXAMPLE 31

dry brush will produce some very good effects. So that the beginner will understand what is meant by "dry brush" I will explain that it is a brush with almost all of the color gone out of it. To increase the dry brush effect you may do this work on a rough paper, such as a water color paper. Don't be afraid to get freedom in this style! Balloon Letters may be drawn upright or on a slant, as shown in the examples.

EXAMPLE 32

These shapes are called balloons. They are used extensively in advertising and in the comic pages of newspapers. Balloons may have any shape or proportion necessary to fit the copy and layout, and to get the results the artist desires. The style of lettering used in balloons should be almost a single stroke letter as shown in the two examples. However, I see no reason why another style of lettering could not be used if it is more in keeping with the rest of the page. Balloons may have a variety of effects. They can be drawn with a one-weight line or a thick-and-thin line. The artist will have to use his own sense of design in planning these shapes.

EXAMPLE 34

This example shows the word "Company" with fine curved lines running through the down strokes of each letter. By putting a very slight curve in these down strokes you can join the letters together, better. You should be

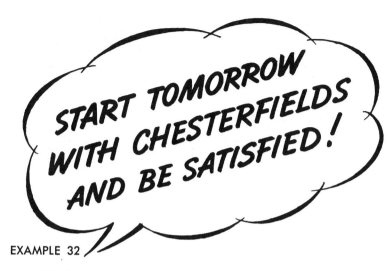

EXAMPLE 32

EXAMPLE 33

careful, however, not to exaggerate this curve as it will take away the style and character. This style may be much freer than the examples shown, but you should retain the style no matter how free you do the work.

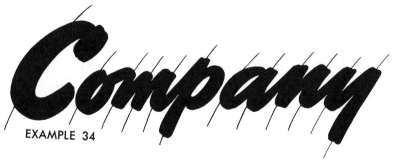

EXAMPLE 34

EXAMPLE 36

You will notice that I have drawn a curved line over which I have lettered the word "Companion". This curved line can be almost straight across, or a more exaggerated curve than I have shown. It may be even the reverse of the curve shown here. You will notice also that the line does not run through the center of each letter. This line was drawn first so as not to give the word an appearance of being too stiff or ordinary. The student or beginner is very apt to draw a *top and bottom line*, then keep his

Companion

EXAMPLE 35

lettering *between* the lines, which is wrong! It is surprising how few lettering artists realize that a little thing like this can ruin the style of lettering. To do this handwriting style, use a *large* brush and bear lightly, or use a *smaller* brush and bear down to get varying results. This will require continued experiment on your part until you get the idea. You will then be able to decide which size brush is most satisfactory to you for the work you are doing.

Show heavy brush lettering both upright and on a slant. To do these types of lettering you should have your brush *loaded* with color and watch the size of the white spaces within and around the letters carefully. By doing it that way you will get a very legible look to your work. This style should have a great amount of freedom. Some of

Lincoln Automobiles

EXAMPLE 36

the letters may slant a little even though the style may be an upright script. Above all try and get plenty of action in the words. I would advise the student to practice doing these styles on some cheap paper until he feels as though he has the idea.

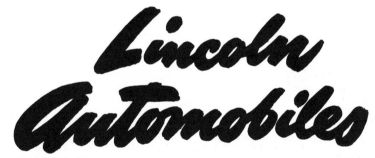

EXAMPLE 37

Flat Pencil Lettering
As used in Modern Advertising Layouts

This section is very important for both student and finished artist. It details a very rapid method of indicating lettering on layouts and roughs. Most art directors use the flat pencil to suggest the style and placement of the lettering wanted.

Artists and typographers use flat pencil layouts as their guides when doing finished work. The art director or visualizer selects a pencil that has sufficient width to do the style of lettering that he wants to indicate.

The following pages were done very quickly (about one-half hour for each page). No attempt was made to make them look like finished drawings. The whole idea is to let the student see the different pencil strokes as they are made. In doing some of these styles I have used a straight-edge to rule my uprights as most art directors do.

Good visualizers make intelligent use of the tools they have. It they can get better result by using a brush instead of a pencil they never hesitate; if the results will be better by ruling the uprights they do so. When using this method the artist must watch the spacing and proportions of the letter as this is more important than accurately drawn letters.

Flat pencil technique requires a vast amount of practise if the student tries to do it without instruction.

Be sure to have your pencil carefully sharpened to a chisel point before you start this style of lettering; then practise holding the pencil in the proper manner. The photos of hands on pages 6 and 7 show this. Study these pictures very carefully and it will help materially. Remember also that a full arm motion is necessary to get good results in many of these styles. In very small letters, however, only a wrist motion is necessary to attain the character desired.

This section also shows various combinations of lettering that go together well. The ability to combine apparently unrelated letter styles harmoniously is most important and should be given serious study when laying out your work. On page 29 is an example of a loose script wording and a heavy, severe letter with serifs.

Chesterfield

cigarettes *They Satisfy*

Madison Square Garden

New York City

For Your Daughter's Wedding Gift

Community
Silverware

Exclusive Models in
PACKARD
Automobiles

To the Champion goes the Trophy

Hunter Whiskey

"First Over the Bars"

Shawmut National Bank

BOSTON MASSACHUSETTS

Spend Your Vacation in **NEW ENGLAND**

Something more than beer...a tradition

Budweiser

HUNTER

An American Gentleman's
Whiskey since 1860

PLYMOUTH

the Car of a Generation

ARMSTRONG LINOLEUM FLOORS

Custom Laid or Standard Designs

Mothers

Guard Against Sudden Temperature Changes

Vacation in the White Mountains

The Refrigerator that satisfies Everybody

I have divided this book into sections so that the artist may find the character of alphabet that he wants without looking through the entire book. Pages 34 to 69, inclusive, are what I call the popular alphabets. These include styles from the classic Caslons (pages 42, 43, 44, 45), Bodoni (pages 46, 47, 48, 49) and the Garamonds (pages 50-51). Most of these styles may be varied in proportions and weights provided the changes are not carried to extremes. On the intervening pages are illustrated many other styles ranging from Classic to Oriental. The English Gothic types on pages 60 and 61, and the Roman type on page 54, are also very old types but are not used as extensively in advertising as the other three. Some of the styles in this section may be done in outline and shadow, as the style on page 66. The width of the outline and shadow may be varied to fit the purpose for which the lettering is being done. The style on page 57 can be done mechanically or free hand, as I do in most cases. The student

should give particular attention to the weights and proportions of all these letters.

Some styles in this book are designed to form good spacing and legibility when put together into words (as styles on pages 36-37). Some of these letters look very

narrow by comparison with the other letters in the alphabet but when words are formed with these letters the spacing and legibility are vastly improved.

Pages 38-39 show a square Gothic letter that can be made either heavier or much lighter than shown without destroying the style. However, the relations between the black and white spaces should be carefully planned and thought out. The English Gothic styles, on pages 60-61, cannot be made much heavier or lighter without destroying the quality of the letters.

Pages 40-41 show a light weight condensed letter that depends mainly in its proportions to give it style. To make this a wider letter the artist can make the down strokes heavier and then leave a trifle more white space between the down strokes.

Pages 48-49 show a style on which the cross or heavy strokes can be made twice as heavy as they are without making the down strokes any heavier than shown. These changes will give it a little more style but may take away from the legibility.

Inasmuch as this is a book on hand lettering, the Caslon styles on pages 42-45 are drawn in quite different proportions than type. I have designed these letters with a more condensed feeling, thereby changing the shapes of all white spaces.

The Bodoni styles on pages 46-49 have been handled with the same condensed feeling as the Caslons. These styles may be made heavier on both the heavy and light strokes. The proportions of almost every style in this section may be changed to fit the job the artist is doing. When an artist can make necessary changes and, at the same time, preserve the characteristics which make a letter distinctive, legible and interesting he is a thorough craftsman.

The style on page 59 depends mainly on its proportion and weight to give it charm and distinction. This is a very beautiful letter when properly handled. A simple one-weight script or handwriting goes well with this style.

Pages 50-51 are Garamond types and should always be done freehand and NEVER RULED. This style calls for careful drawing and I here call attention of the inexperienced to the slight difference in the weights of the heavy and light strokes. Also note the various slants of the letters as this is a strong characteristic of Garamond.

Page 58 shows a very condensed letter with a serif and should never be made wider than shown but could be made a little more condensed.

Page 69 shows a letter that can be used almost anywhere. Caslon Italic goes very well with it when laying out the advertising page.

Pages 54-55 are quite different, yet, at first glance, have a similar look. These are very beautiful letters when used in their proper places.

These letter forms are particularly suitable for use with classical associations, either literary, as book jackets and book covers, or in architectural connections, where the classic tradition is still preserved. Page 54 follows closely the true "Attic tradition", so beautifully perfected by the early Roman school in their chiseled inscriptions. Page 55, on the other hand, is somewhat more free in variety of stroke and serif form, but still retains its readability and the true character-forms established and passed down to us by the early Fathers of our alphabet. These Roman forms are perhaps the finest inspiration ever arrived at in lettering, being a direct inspiration, more than the slow and gradual evolution which characterized most other alphabets.

ABCDEFGHI
JKLMNOPQR
STUVWXYZ&
123456789

a b c d e f g h i
j k l m n o p q r
s t u v w x y z ?

A B C D E F G H I
J K L M N O P Q R
S T U V W X Y Z ?
1 2 3 4 5 6 7 8 9

a b c d e f g h i
j k l m n o p q r
s t u v w x y z !

A B C D E F G H I

J K L M N O P Q R

S T U V W X Y Z &

abcdefghijklm
nopqrstuvwxyz
123456789

ABCDEFG

HIJKLMN

OPQRSTU

VWXYZ&

abcdefghi
jklmnopq
rstuvwxyz
123456789

ABCDEFG
HIJKLMN
OPQRSTU
VWXYZ&!

44

abcdefghijklmn

opqrstuvwxyz

123456789

ABCDEFG
HIJKLMN
OPQRSTU
VWXYZ&!

abcdefghijklmn

opqrstuvwxyz!

123456789

A B C D E F G
H I J K L M N
O P Q R S T U
V W X Y & Z !

a b c d e f g h i
j k l m n o p q r
s t u v w x y z !
1 2 3 4 5 6 7 8 9

ABCDEFGHIJ
KLMNOPQRS
TUVWXYZabcd
efghijklmnopqrst
uvwxyz·1234567890

ABCDEFGHI
JKLMNOPQR
STUVWXYZ&

abcdefghijklm
nopqrstuvwxyz

ABCDEFGHI
JKLMNOPQR
STUVWXYZ&

abcdefghijklm
nopqrstuvwxyz
· 123456789 ·

ABCDEFG

HIJKLMN

OPQRSTU

VWXYZ&

ABCDEFGHI
JKLMNOPQR
STUVWXYZ$
123456789

ABCDEFGHIJ
KLMNOPQR
STUVWXYZ
123456789

A B C D E F G H I
J K L M N O P Q
R S T U V W X Y Z
1 2 3 4 5 6 7 8 9 0

ABCDEFGHIJKLMNOPQR

STUVWXYZ&123456789

abcdefghijklmnopqrstuvwxyz

58

ABCDEFGHIJKLMN

OPQRSTUVWXYZ&

abcdefghijklmnopqrstuvwxyz

A B C D E F

G H I K L M

N O P Q R S

TUVWXYZ

abcdefghijklmn

opqrstuvwxyz

ABCDEFG
HIJKLMN
OPQRSTU
VWXYZ&!

abcdefghi
jklmnopqr
stuvwxyz
123456789

ABCDEFGHIIKL
MNOPQRSTUV
WXYZ1234567 89

abcdefghijklmn
opqrstuvwxyz&

A B C D E F G H I J K L

M N O P Q R S T U V W

X Y Z 1 2 3 4 5 6 7 8 9

a b c d e f g h i j k l m n

o p q r s t u v w x y z &

ABCDEFG

HIJKLMN

OPQRSTU

VWXYZ&!

ABCDEFGHIJKL

MNOPQRSTUVW

XYZ·123456789

ABCDEFGHI
JKLMNOPQR
STUVWXYZ&
123456789

A B C D E F G H I
J K L M N O P Q R
S T U V W X Y Z &
1 2 3 4 5 6 7 8 9

Pages 72 to 86 show a variety of Scripts. The examples shown were selected because the lettering artist can produce practically every desired type of script letter using those in this book as a foundation, and guide.

Scripts fall naturally into two classifications . . . Formal and Informal. All Scripts convey the impression of handwriting and can be made very interesting and expressive when properly handled. Naturally, to be able to do this requires knowledge of the various styles, a real artistic sense in choosing the lettering best suited to the idea as well as the ability to draw them correctly.

Handwriting, or Informal Script, is decidedly popular with advertisers today. Its use often endows a piece of advertising with an air which cannot possibly be achieved with type. Various styles of Informal Script express youth, freedom, speed, action, lightness, etc.

Many people connect Formal Script almost exclusively with wedding invitations, announcements and the like. Its use, however, is much broader and advertisers use it quite extensively, especially in magazine advertisements.

Whenever Script, Formal or Informal, is used there is a definite reason for doing so; the unusual shape and character of the letters contrasted to the angular corners of photographs and blocks of type on the same page lend life and action to what might otherwise be a static or stodgy advertisement, lacking interest and variety.

Scripts are not easy to do well. The tools used are very important. Sometimes better results are obtained with a brush than with a pen; also the type and size of pen or brush are important. One cannot get brush character to lettering with a pen nor pen character with a brush. This applies particularly to Informal Scripts.

The many different characters, weights, slants, etc., make Script an interesting lettering problem. After the style has been decided the artist must lay out his work

so that ALL lines in each word appear to be continuous. In completing the job great care must be taken in joining the letters, or the result will look very ordinary.

In teaching Informal Script I never teach the shape of the letters. I stress what I choose to call "continuous motion" so as to get a flowing effect. While all the same letters must have the same character they should not look like perfect tracings of one another. In short, what the artist is trying to express with Informal Script is freedom of action; if he is too conscious of the shape of each letter the word may appear too mechanical and fail to convey the impression of freedom and the action of handwriting. Another way to give this style action is to avoid having all letters exactly the same height. Some of the flat pencil examples will show how to connect the letters properly, without mechanical effect.

A little additional weight in these letters changes their appearance; it fills up the white space quickly since they are connected letters.

The student should practise these styles with various types of pens. When he thoroughly understands what gives the letters style he can then start to draw them getting that extra bit of style that every letterer strives to attain. Do not be too easily satisfied with your progress; you must practise continuously and conscientiously, but to make rapid and really marked progress it is best to get competent instruction.

Formal Script, on the other hand, must be done VERY carefully . . . tightly. Judgment must be used in spacing and the same letters must be absolute duplicates of each other.

Some of the headings on the following pages were done in less than five minutes each, and one was done in less than one minute. Some of the rapidly lettered headings were done with a Speed Ball pen. The others were done with brush or drawing pen. No attempt was made to see how well I could draw these styles as this book is to help the student to get the fundamentals of these letters and not the definite shapes. So that this book may prove most helpful I have put in the complete, carefully drawn alphabets of Capitals and lower case letters of these Scripts. The artist, of course, should put some of his own individuality into the capitals and into the lower case; but unless he understands these styles he will be safer to follow closely the styles in the book. This will instruct the student in the true fundamentals of the letters, and from that basic knowledge he can proceed with his own individual interpretations.

ABCDEFG

HIJKLM

NOPQRS

$T\ U\ W\ X\ Y\ Z$

$A\ a\ b\ b\ c\ d\ e\ f\ f\ f\ g\ h\ h\ h\ i\ j\ k\ k\ l\ l\ m\ n$

$o\ p\ p\ q\ q\ r\ s\ s\ f\ t\ t\ u\ u\ v\ v\ x\ y\ z.$

$1\ 2\ 3\ 4\ 5\ 6\ 7\ 8\ 9\ 0.$

A B C D E F G

H I J J K L M

N O P Q R S T

U V W X Y Z

a b c d e f g h i

j k l m n o p q r

s s t u v w x y z

1 2 3 4 5 6 7 8 9

ABCDE7G
HIJKLM
NOPQRST
UVWXYZ

abcdefghi
jkkklmnopqr
ssttuvwxyz
1 2 3 4 5 6 7 8 9

ABCDEFG

HIJKLM

NOPQRST

TUVWXYZ

abcdefghijklmn

opqrrstuvwxyz

The Aristocrat of fine Champagnes

Advertising for Christmas Displays

Clothing Fashions for Spring

Advertising for Christmas Displays

Send Flowers or Candy on Mothers Day

Right Combination...World's Best Tobaccos

Community the Finest Silverplate

New York Welcomes Your Customers

A Merry Christmas from Yardley

American Broadcasting Company

Chesterfield Cigarettes...They Satisfy

Yardley Products are Created in England

Fashions from London England

Fashions from London England

Fashions from London England

HEAVY LETTERING

Heavy letters are very popular with most art students today due to the many posters, packages and displays that they are required to do in art school. They like the power and strength of these letters and usually get good results in their finished work mainly because the letters seldom have serifs. On the magazine advertising page they are used for emphasis without eating up too much space. They lend "color" to a page and are decidedly legible when not crowded.

Few artists can do Heavy Lettering and still keep style in the letter. This calls for extreme care in the weights of the different strokes. Too much measuring to keep all the strokes the same weight gives the letters a mechanical look and thereby they lose charm and character. Only by experimenting can you finally decide which are the proper weight and proportion.

Posters are the one form of advertising in which Heavy lettering is used most frequently. When lettering posters it must be remembered that they are intended to be read from a distance. Legibility, therefore, is an absolute necessity and the letters must be formed, spaced and proportioned with the functional value of the poster constantly in mind.

When using heavy lettering on a poster the student should consider the distance from which it will have to be read; also that a person usually is moving while reading the poster. For these reasons the artist must be very careful to consider legibility in which spacing plays a most important part. Try making two or three quick roughs; then stand about ten feet away from them to see whether the lettering can be read easily. After a while you will be able to select the proper style and weight without guessing or experimenting.

The beginner often is deceived into thinking that heavy lettering is very easy to do well. It may look easy but it requires just as much skill, knowledge, technique and ability to draw perfect, artistic heavy lettering as it does to do the lighter styles.

ABCDEFG
HIJKLMN
OPQRSTU
VWXYZ!&

abcdefghi
jklmnopqr
stuvwxyz!
123456789

ABCDEFG
HIJKLMN
OPQRSTU
VWXYZ&!

abcdefghi
jklmnopqr
stuvwxyz!
123456789

ABCDEFGHI
JKLMNOPQR
STUVWXYZ&
123456789

abcdefghi

jklmnopqr

stuvwxyz?

ABCDEFGHI
JKLMNOPQR
STUVWXYZ

abcdefghijklm
nopqrstuvwx
yz 123456789

ABCDEFG
HIJKLMN
OPQRSTU
VWXYZ&

abcdefghi
jklmnopqr
stuvwxyz&
123456789

ABCDEFG
HIJKLMN
OPQRSTU
VWXYZ!&

abcdefghi
jklmnopqr
stuvwxyz!
123456789

ABCDEFG
HIJKLMN
OPQRSTU
VWXYZ&

abcdefghi
jklmnopqr
stuvwxyz!
123456789

A B C D E F G
H I J K L M N
O P Q R S T U
V W X Y Z &

abcdefghi
jklmnopqr
stuvwxyz!
123456789

ABCDEFG

HIJKLMN

OPQRSTU

VWXYZ&!

abcdefghi
jklmnopqr
stuvwxyz!
123456789

ABCDEFG
HIJKLMN
OPQRSTU
VWXYZ&!

abcdefghi
jklmnopq
rstuvwxyz
123456789

A B C D E F
G H I J K L M
N O P Q R S

T N V V W X Y Z

abcdefghijklmn

opqrstuvwxyz

ABCDEFGHI
JKLMNOPQR
STUVWXYZ?

ABCDEFGHI
JKLMNOPQR
STUVWXYZ?

ABCDEFGHI

JKLMNOPQ

RSTUVWXYZ

abcdefghijklmn

opqrstuvwxyz!

This section of the book contains eight pages of Old Fashioned Lettering styles such as frequently are used in modern magazines and newspapers.

Few styles other than Old Fashioned instantly convey the suggestion of antiquity.

Because of the suggestion of age Old Fashioned lettering frequently is used on whiskey bottle labels. Another modern use for Old Fashioned lettering is on title pages and book jackets for novels, the plots of which are laid in the early or middle part of the past century.

Old Fashioned cannot truly be said to be a classic letter. It should be placed among the ornate letters, different styles of which enjoyed great popularity while they were in vogue. Just now Old Fashioned lettering is enjoying a revival.

Old Fashioned lettering can be used with formal scripts as on pages 72 and 73. Lines or words of lettering drawn in script with lines or words drawn in Old Fashioned style make a most interesting and pleasing combination. The weights of the letters may be varied with good results but in no case should they be drawn clumsily. The more ornate the style the more sparingly it should be used. In other words, use only one or two words of ornate letters to give emphasis, distinction and charm to the entire page. The other lettering should be plain.

ABCDEFGHI
JKLMNOPQR
STUVWXYZ?

abcdefghijklm
nopqrstuvwxyz

113

ABCDEFGHI

JKLMNOPQR

STUVWXYZ&

123456789

ABCDEFGHI
JKLMNOPQR
STUVWXYZ&
123456789

ABCDEFGHI
JKLMNOPQR
STUVWXYZ&

abcdefghijklmn
opqrstuvwxyz

ABCDEFGHI

JKLMNOPQR

STUVWXYZ&

123456789

ABCDEFGHI
JKLMNOPQR
STUVWXYZ&
123456789

ABCDEFGHI
JKLMNOPQR
STUVWXYZ&
123456789

A B C D E F G H I
J K L M N O P Q R
S T U V W X Y Z &
1 2 3 4 5 6 7 8 9

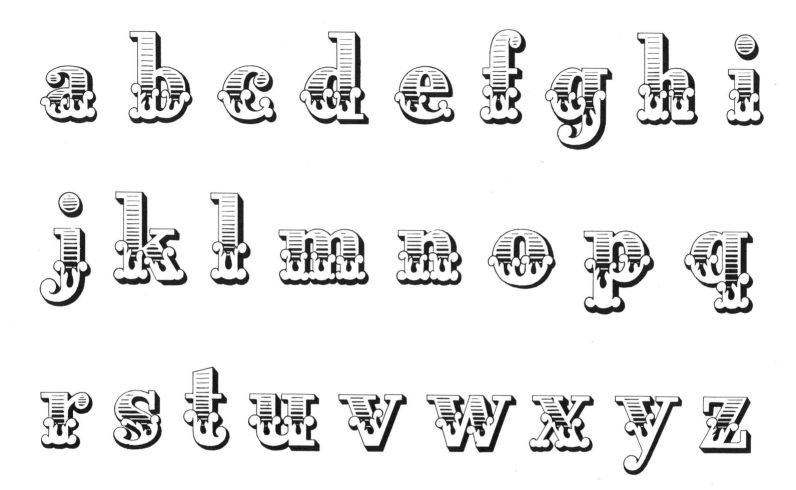